# Contents

Introduction
Supplies
Why I paint?
Inspiration and Quotes
1. Getting Started
2. Painting step by step
3. Finishing Touches
4. Where to find inspiration
5. Examples of paintings
Bibliography
About the Author

# Introduction

Thank you for opening this book and allowing me to share with you my 30-year art journey.

I have been teaching painting for more than 16 years, and my students and I have found that painting has therapeutic benefits.

My hope is that by painting, you can experience the fun, relaxing process that is more valuable than the product.

# Watercolor supplies
## (that I use)

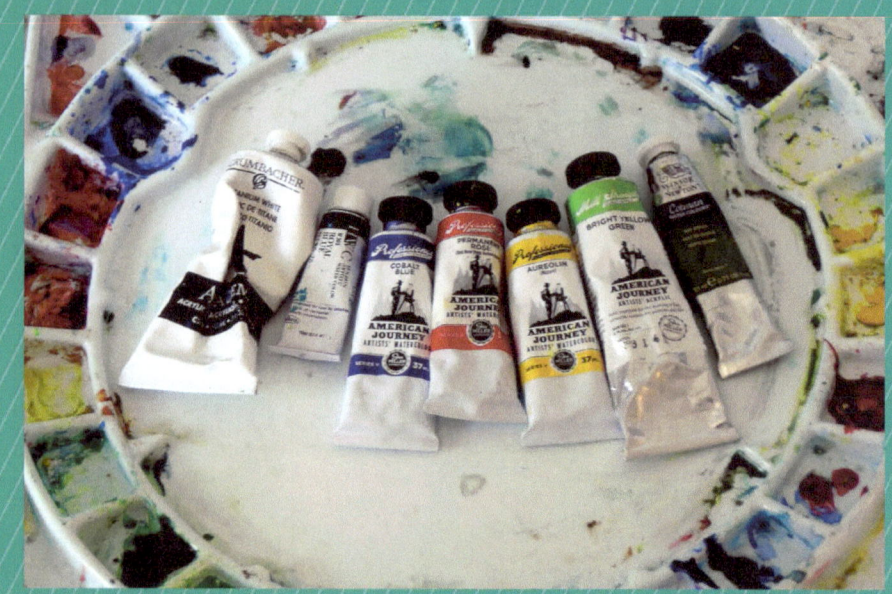

For most of my supplies:
www.
cheapjoes.com

# Brushes & More

(I use these brush sizes most often, but experiment)

- FLAT BRUSHES - 1/2 " angle
- ROUNDS - 12", 8", 1",
- PALETTE KNIFE - for scraping
- #2 PENCIL with KNEADED ERASER
- TOOTHBRUSH - for spatter
- PITT PEN - or other permanent marker for ink work

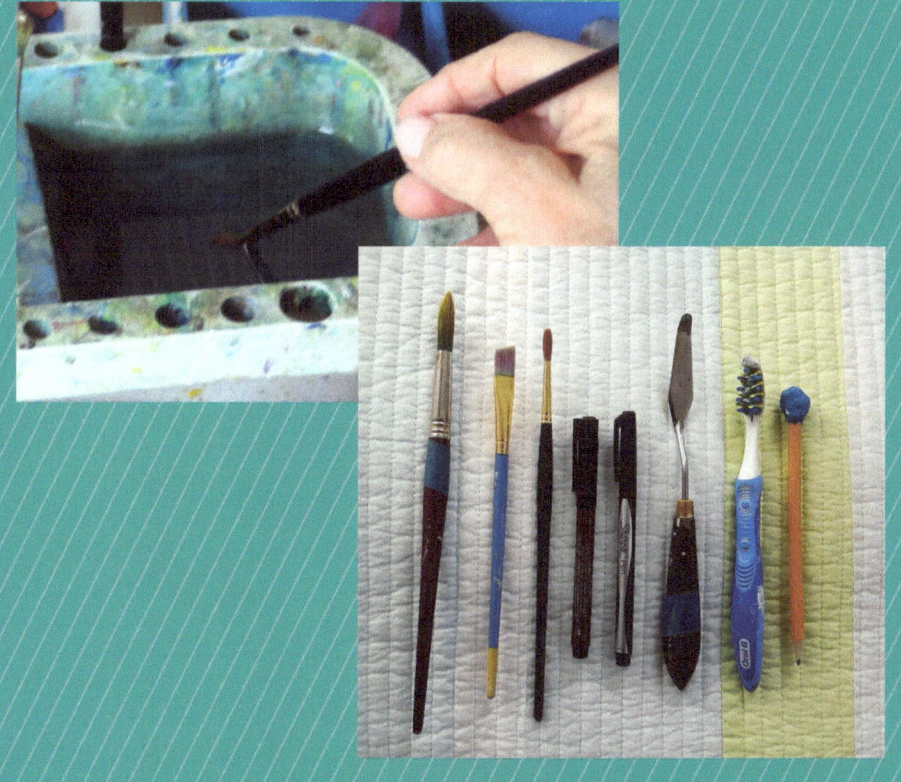

Paints. Use tube paints

Red- cadmium red, perm. rose
Blue-Cobalt blue
Yellow- Cadmium yellow
White -is the paper, but I use white acrylic for corrections
Black-Peach Black by Holbein
Green-mix blue and yellow
Orange-mix red and yellow
Purple- mix blue and red
Brown-Raw Sienna

Palette:
You can use a white plate to put your paint on or a palette. I like the supplies found at cheapjoes.com

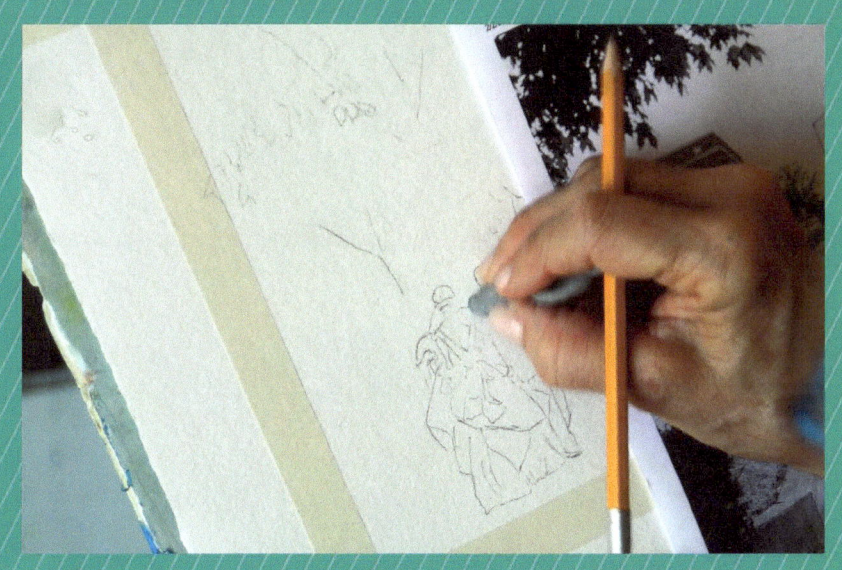

# Paper & Misc.

- **PAPER** - 140lb. cold press water color paper. I prefer Arches, or Fabriano
- **TAPE** - Masking tape to tape the paper to a foam core surface
- **WATER CONTAINER** - A brush holder/water container
- **PAPER TOWELS**
- **TOILET TISSUE** - For blotting

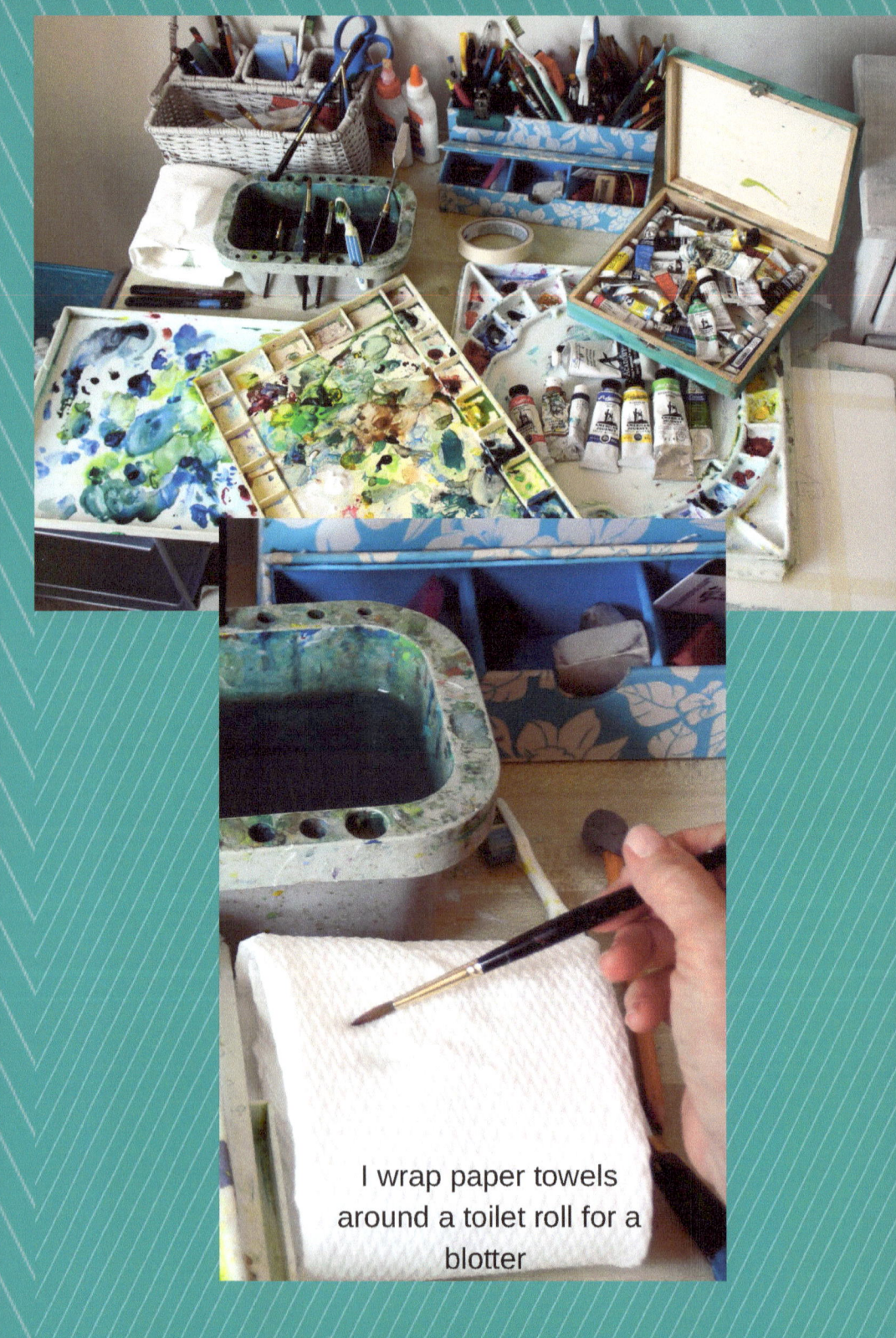

I wrap paper towels around a toilet roll for a blotter

# Why I Paint

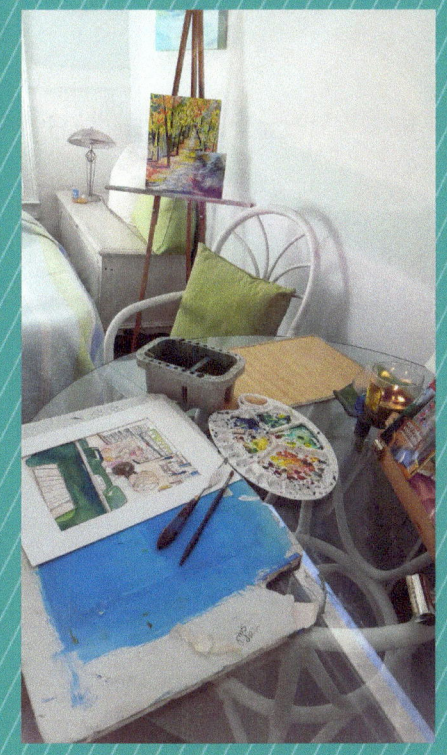

Over 40 years ago, I graduated from Hollins University in Virginia, with a degree in pre-med, and teaching certification. I wasn't happy with my career choices and decided to sell real estate, advertising and later teach art. It was at age 28, while selling advertising in Atlanta, that I began taking graphic design, and art lessons.

The next year, I got married and began a family. My former husband and I made the decision

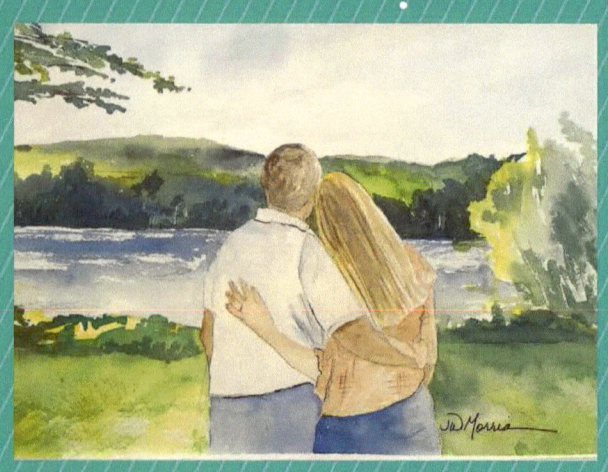

that I would stay home and work part-time. One of my jobs was teaching art.

When I later had marital problems, raising young children problems, teenager problems, health problems, aging parent problems, etc., I discovered I could slip away and cross the bridge to the art world and be in the RIGHT-BRAIN MODE, that feels calming to me. Painting became and remains my therapy.

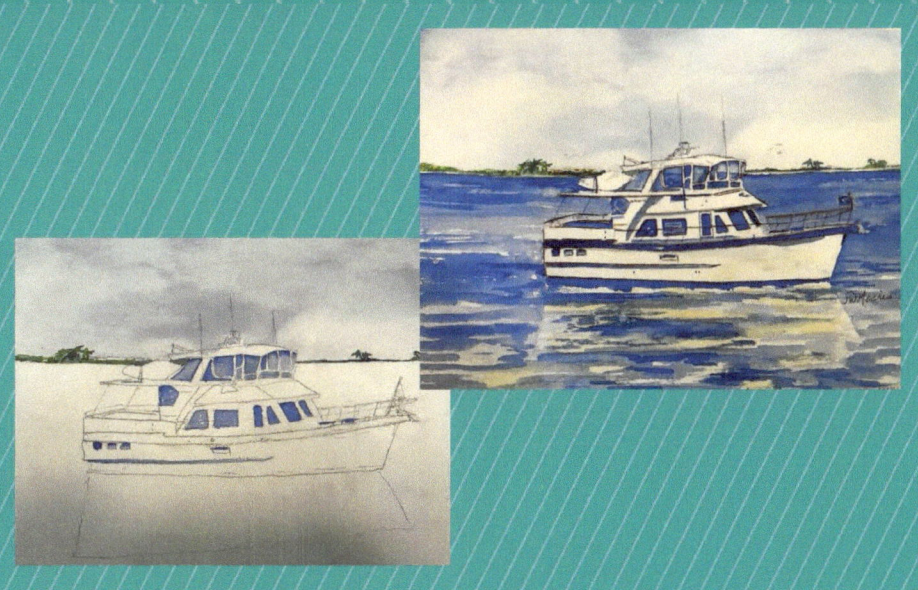

Research shows that when you are in the RIGHT BRAIN MODE, your body secretes hormones, called endorphines that make you feel relaxed.

 This Right brain mode is sometimes called the flow, or state of meditation. Research shows that this right brain mode can have a healing effect. Check out the books on art in my bliogaphy.

# FAVORITE QUOTES

"Be miserable or motivate yourself, the choice is always yours." - Wayne Dyer

"Imagination rules the world"- Napolean Bonaparte

"Failure helps you discover yourself" - JK Rowling

ASK. Ask and you shall receive, Seek and you shall find, Knock and the door shall open.  Matt 7:7

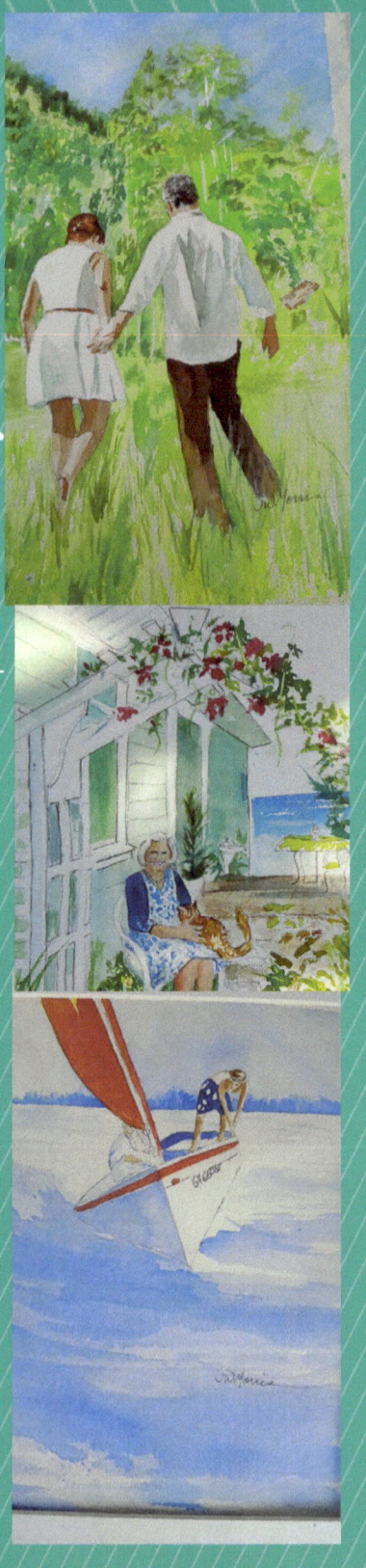

"Nothing about my life is about luck'" - Oprah Winfrey

"We are all stars, we have to figure out what we are suppose to do" - Beyonce'

"Happy will follow, if you are busy painting!" - Jilly Willy

"Making something, even imperfectly is empowering because it's an expression of the self"-Alton & Carrie Barron, MD

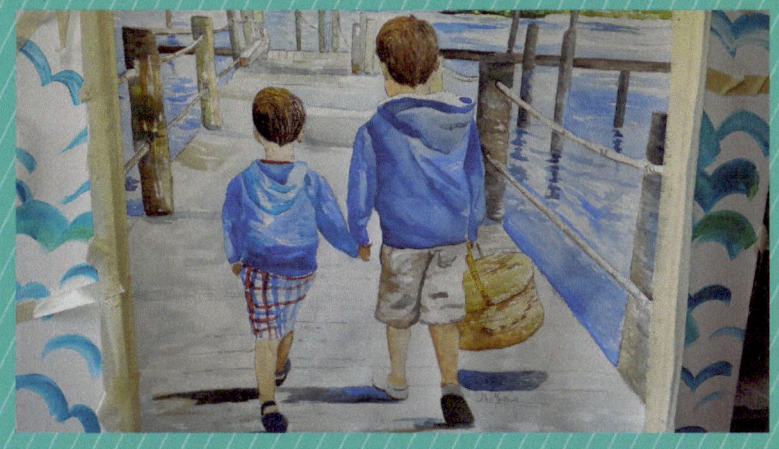

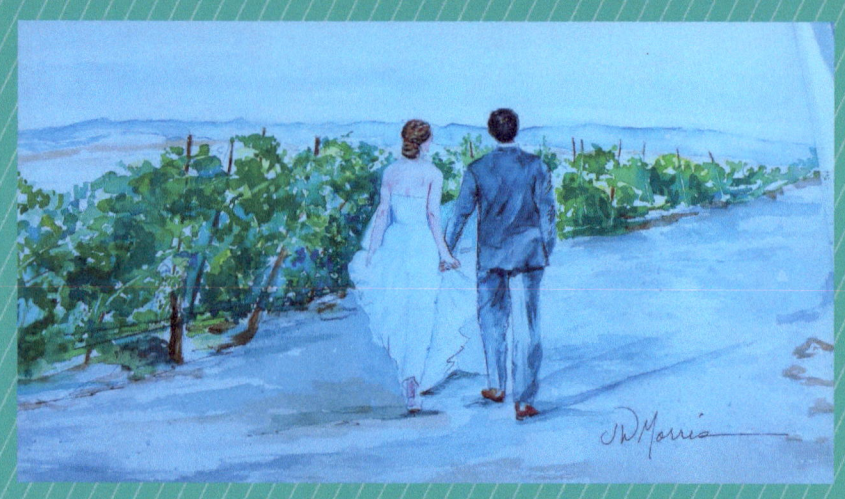

"If we really love ourselves, everything in our life works.'
-Louise Hay, the Godmother of Self Help

"No one can make you feel inferior without your consent."
-Eleanor Roosevelt

"God will not have his work made manifest by cowards."
-Ralph Waldo Emerson

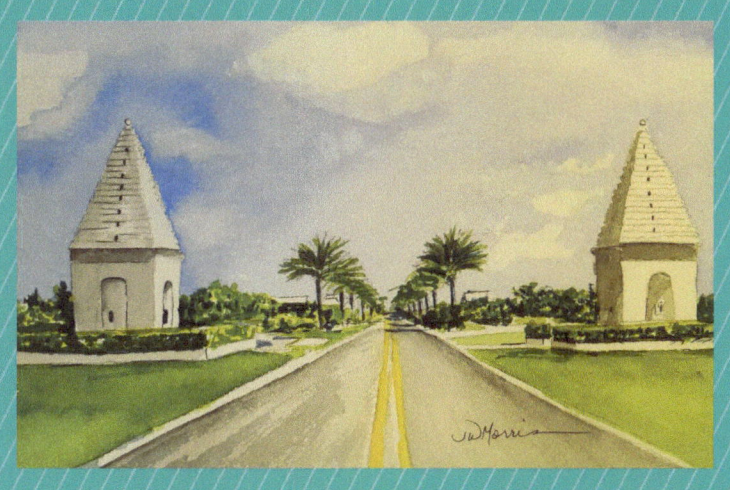

"The best thing about getting older is passing on the baton to younger people who have love, and positive energy. What is love and positive energy? That is God's power, and you can learn to tap into it. Paint Therapy is one way that I tap into God's power."

-Jill Snyder Morris

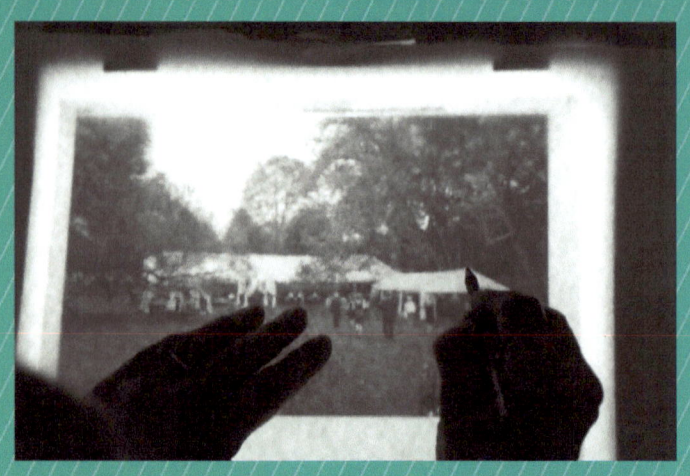

## 1. GETTING STARTED

- Light a candle
- Turn on music without words so that you can enter your right brain more easily
- Choose a personal photo that you love. I print them ahead of time to 8x10 size
- If you like to draw, then lightly draw your image on the watercolor paper. If you don't want to draw, then trace your image with a light table or

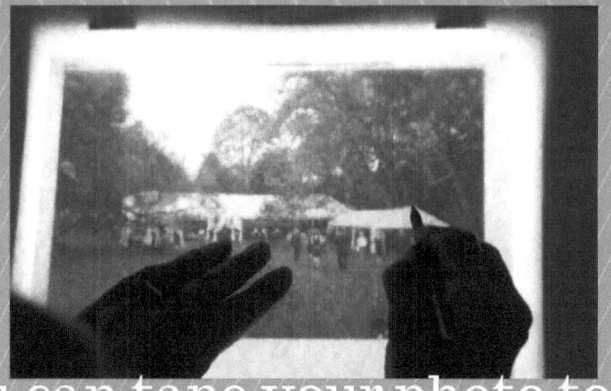

- You can tape your photo to a well lit window, tape your watercolor paper to the window, then tape your watercolor paper over the image, and trace the image. I learned this FAST method while working in advertising, but I recommend you get a sketch book and draw everyday. Carry your sketchbook with you and journal when you draw. I have tons of these books and they make sweet memories. You can watch youtube videos for more instruction if you like drawing.

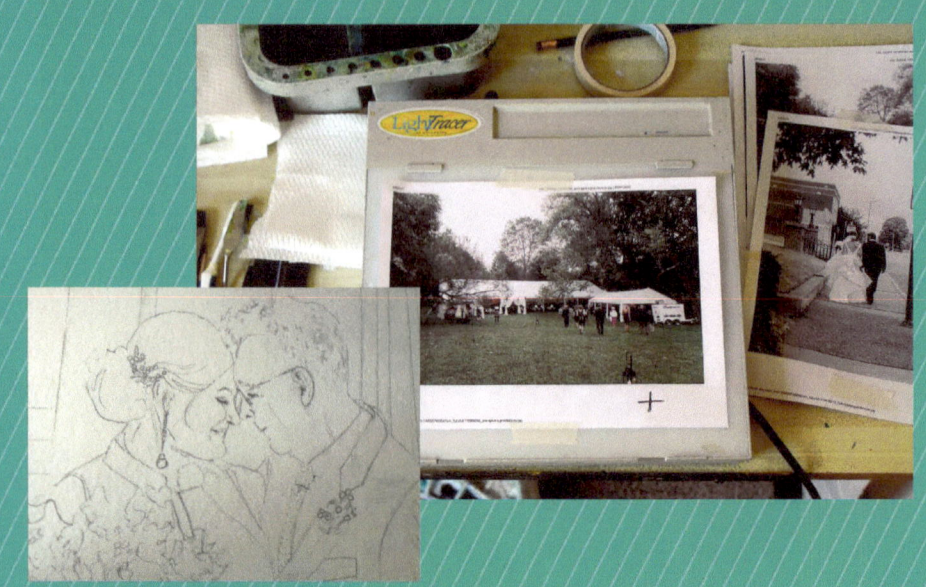

- After I get the BIG shapes, I fill in details, by observing the photo.
- I try not to erase much, as this damages the watercolor paper.
- After I get the image on the paper, I tape my paper to foam core board so that I can tilt my board when I paint.
- Stop at this point, and squeeze out dime size fresh paint that you will use, and get other supplies ready.

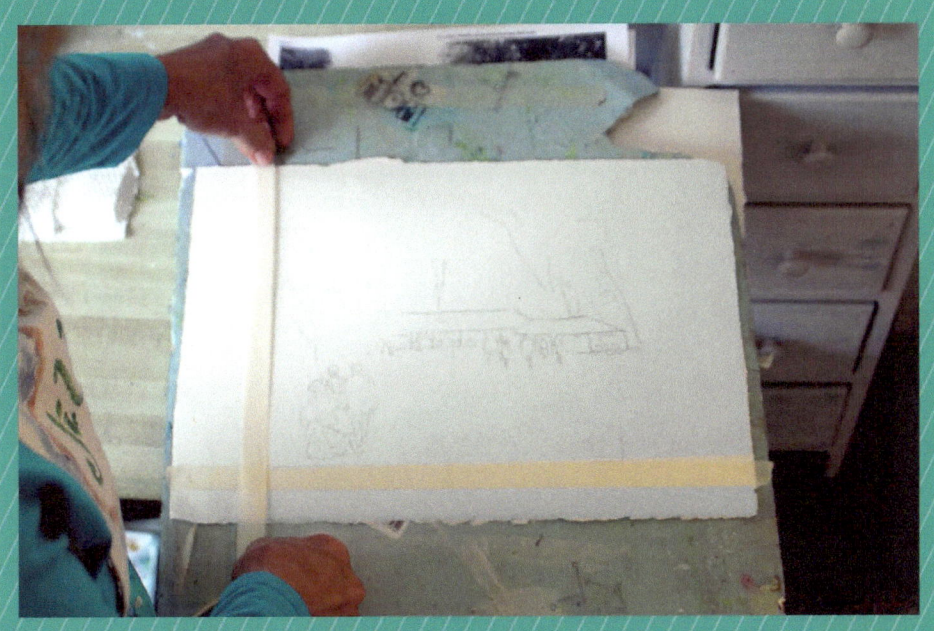

- Sometimes I need to use two photos to get my images on the watercolor paper.
- After I have finished drawing, I tape my watercolor paper to a form core or other hard surface so that I can tilt my board to paint.  Sometimes I paint upside down so that the water colors smerge (mix) together.

# 2. Painting

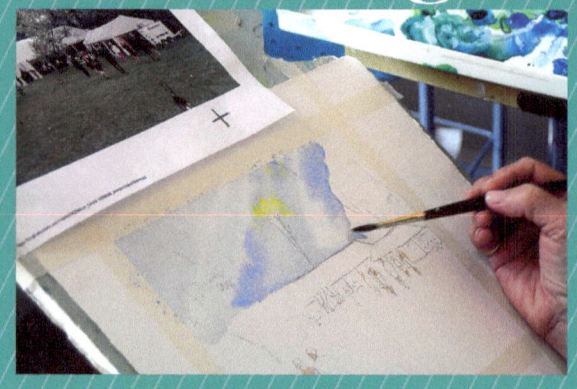

- I usually start with the background and then work towards the foreground. I always start with dry paper, then as I paint, the paper becomes wet and this helps the painting to look loose. I use a combination of dry/wet paper.
- You can learn these techniques by watching youtube videos or taking workshops. I recommend both ways to learn. It takes brush time, and patience.

- You can do this!
- Practice on scrap paper.

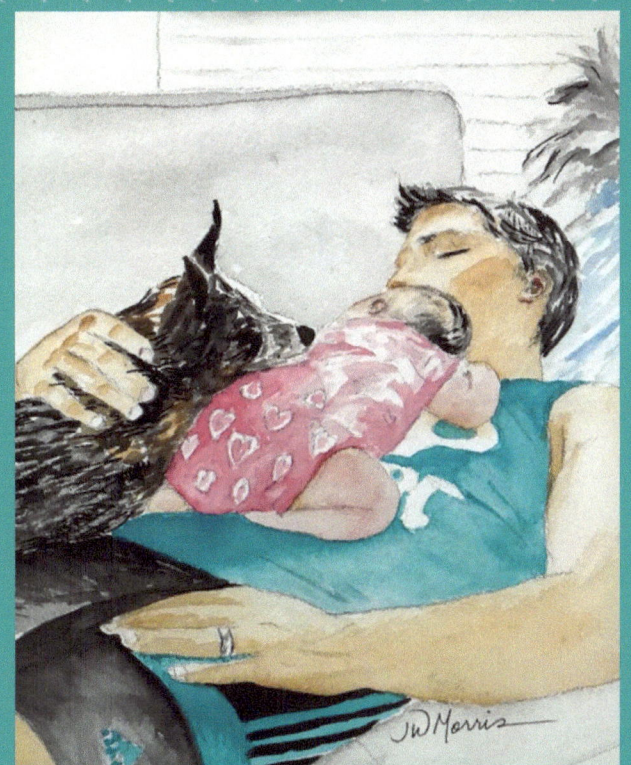

- While painting, work background to foreground, light to dark, top to bottom. I paint large areas with a big brush, then I paint in details with a smaller brush.
- Foliage is one of my favorites to paint. I like to turn my board upside down to let the watercolor run down the board.

- When I have people, I start with the flesh first. Let it dry, then add darker values, (lights, mids, darks).

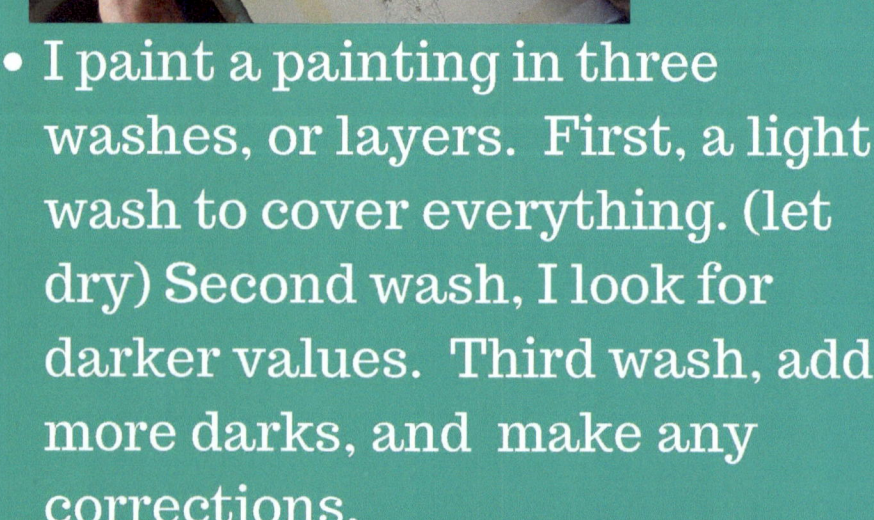

- I paint a painting in three washes, or layers. First, a light wash to cover everything. (let dry) Second wash, I look for darker values. Third wash, add more darks, and make any corrections.

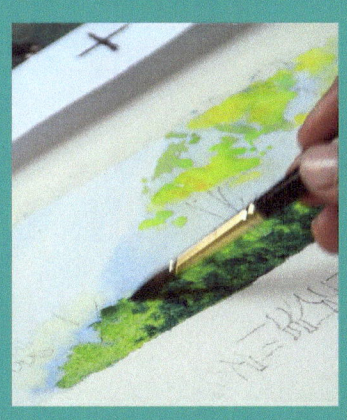
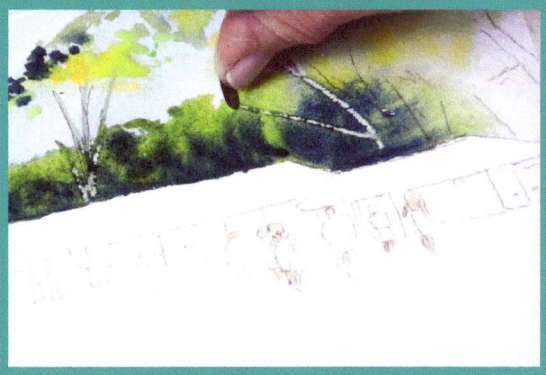

- Palette Knife- I use a palette knife to scrape in tree trunks and other marks.  You can use a credit card if you don't have a palette knife.
- After I scrape in a mark, I paint a darker color behind the mark to make it stand out more.
- Add scrape marks while the paint is wet.

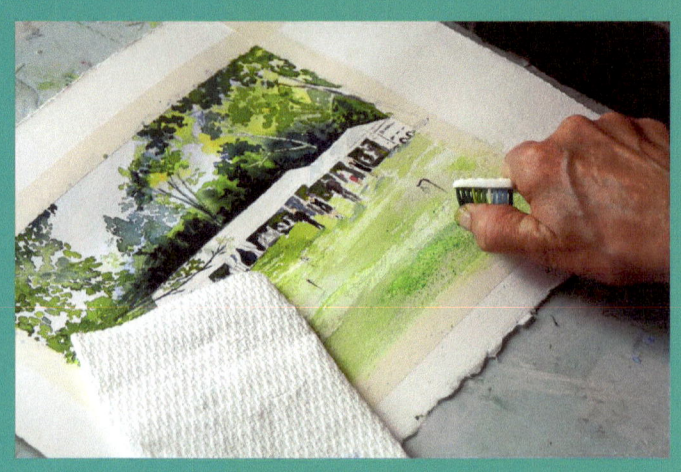

- If you scrape too soon, you will get an indention in the paper, that will fill with paint as you paint and make a dark mark. A dark mark can look awesome too! Just play. Relax! Experiment. Nina Fritz, one of my favorite watercolor teachers told me "you learn by brush time".
- I like to add texture to the grass, sand, etc. with a toothbrush (spatter).

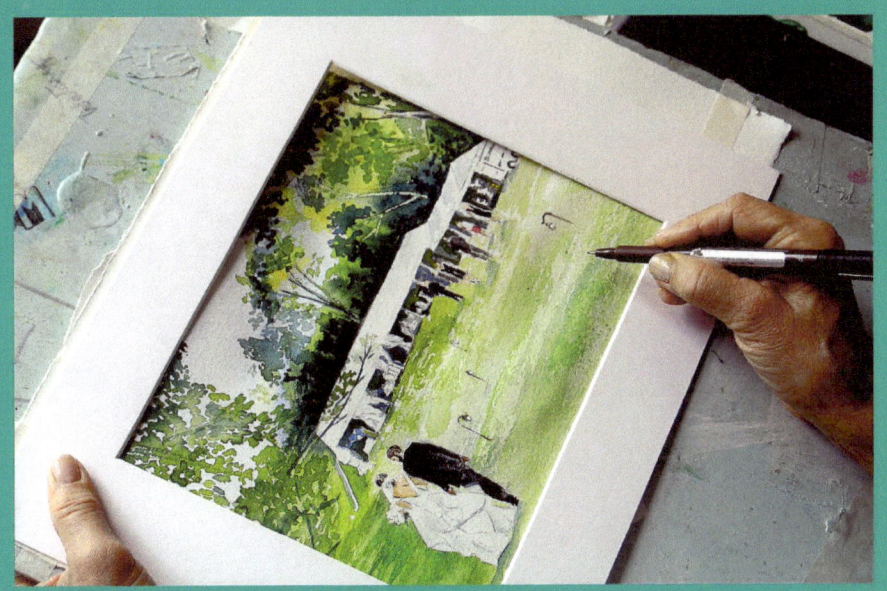

- I usually sign my paintings with a Pitt pen.  A Pitt pen is a perm. marker that won't run.  I usually sign with the fine marker and then look for any other areas that might need a line.  Vary your lines.  You can watch youtube videos on pen and ink work.  I call my paintings watercolor with pen and ink.
- Practice your signature on scrap paper until it is automatic.
- I aways add the mat first to make sure where I want to sign.

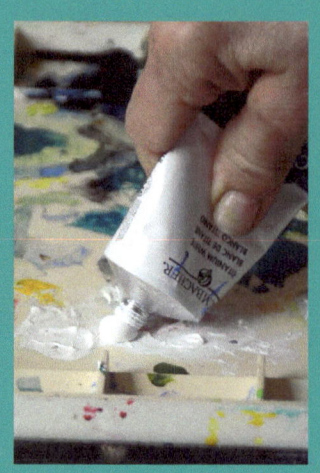
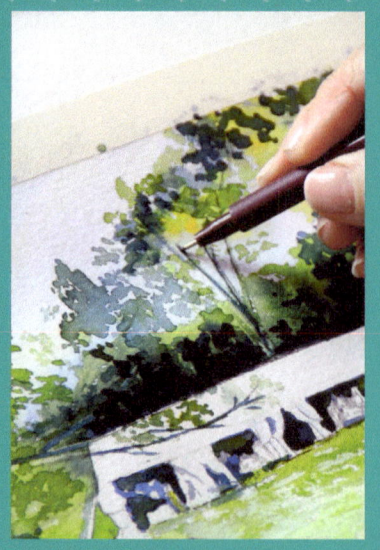

- To make corrections, use acrylic white (zinc or titanium). Just like you would paint a house, the first thin coat primes the mistake, the following layers cover. I try to keep the acrylic light so that it doesn't look thick and too opaque. Let the acrylic dry between coats so that you don't use too much.

- When I think I am finished, I look at the photo of the painting to see if there are any corrections, then I send the proof to the client, or I wait until the next day so that I make sure I don't want to add more darks, or make any other corrections. I rarely add more darks or make further corrections. It is better to have a fresh mistake than an overworked correction.

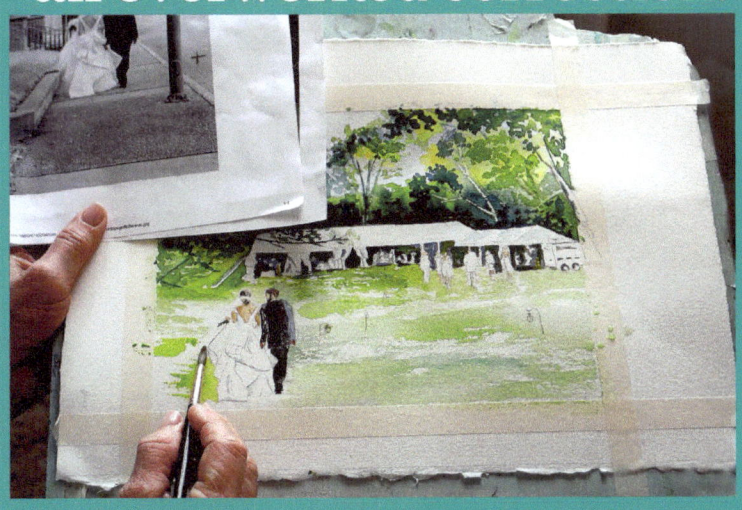

# Finishing Touches

- To finish the painting, I crop the edges with a cutter, and put the painting in a show kit that I buy from Clearbags.com.  This showkit includes, mat, backing board, and plastic protector sheet.

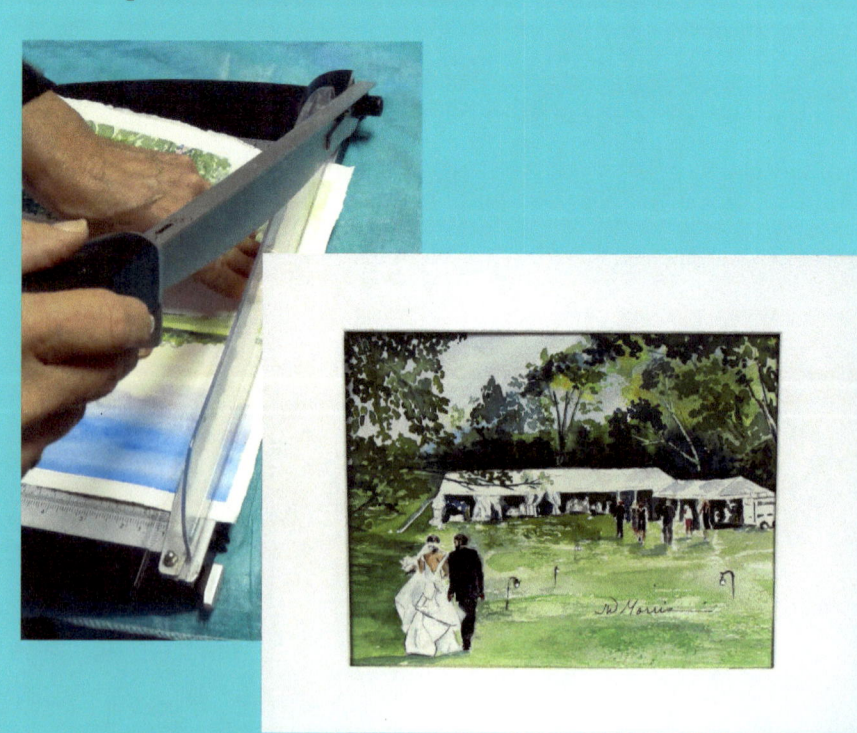

When I started painting 40 years ago, I had no idea I would eventually teach art. I love to travel with friends to workshops and as an empty nester, I now have hours to paint by myself. Paint Therapy is helping me heal!

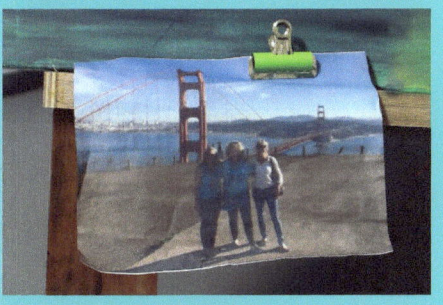
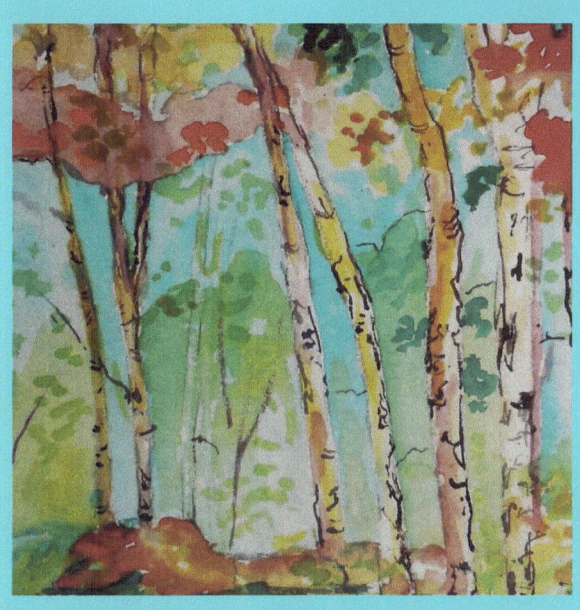

# 4. Inspiration

I find inspirational photos everywhere: family/friends, sport events nature, pets.

One of my favorite past times is to watch youtube videos.

I get many ideas watching other people paint, speak, exercise, etc.

Paint therapy is something you can do by yourself or with others! Rain or shine.

# 5. Painting Examples

## *JillyWillyArt.com*

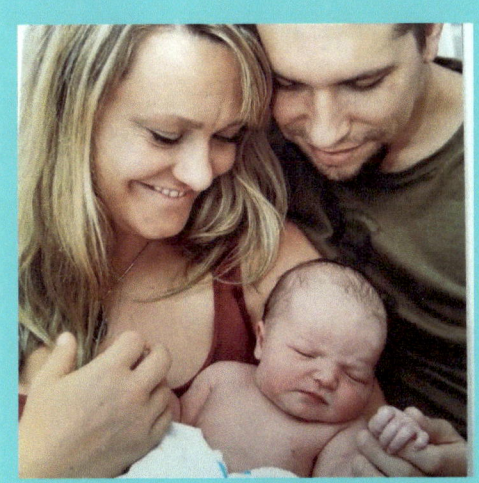
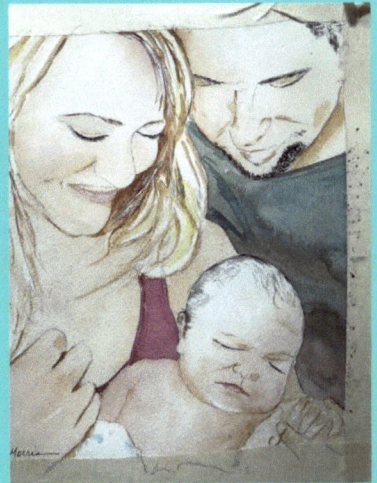
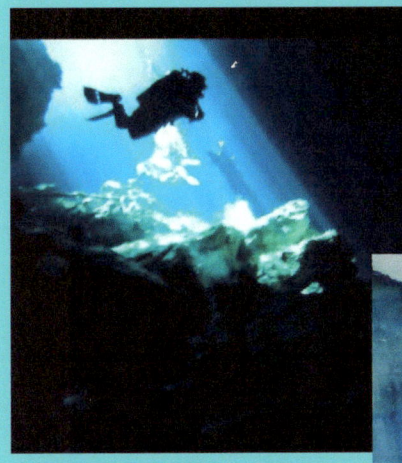
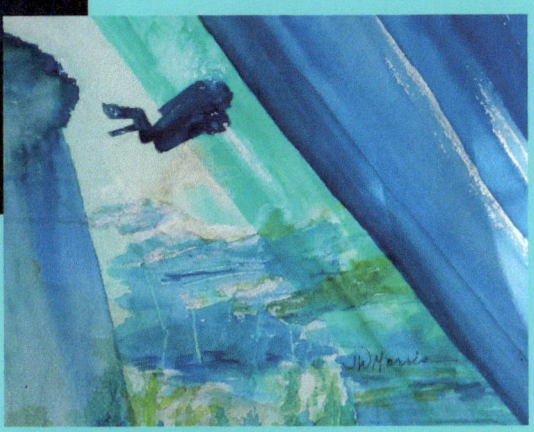

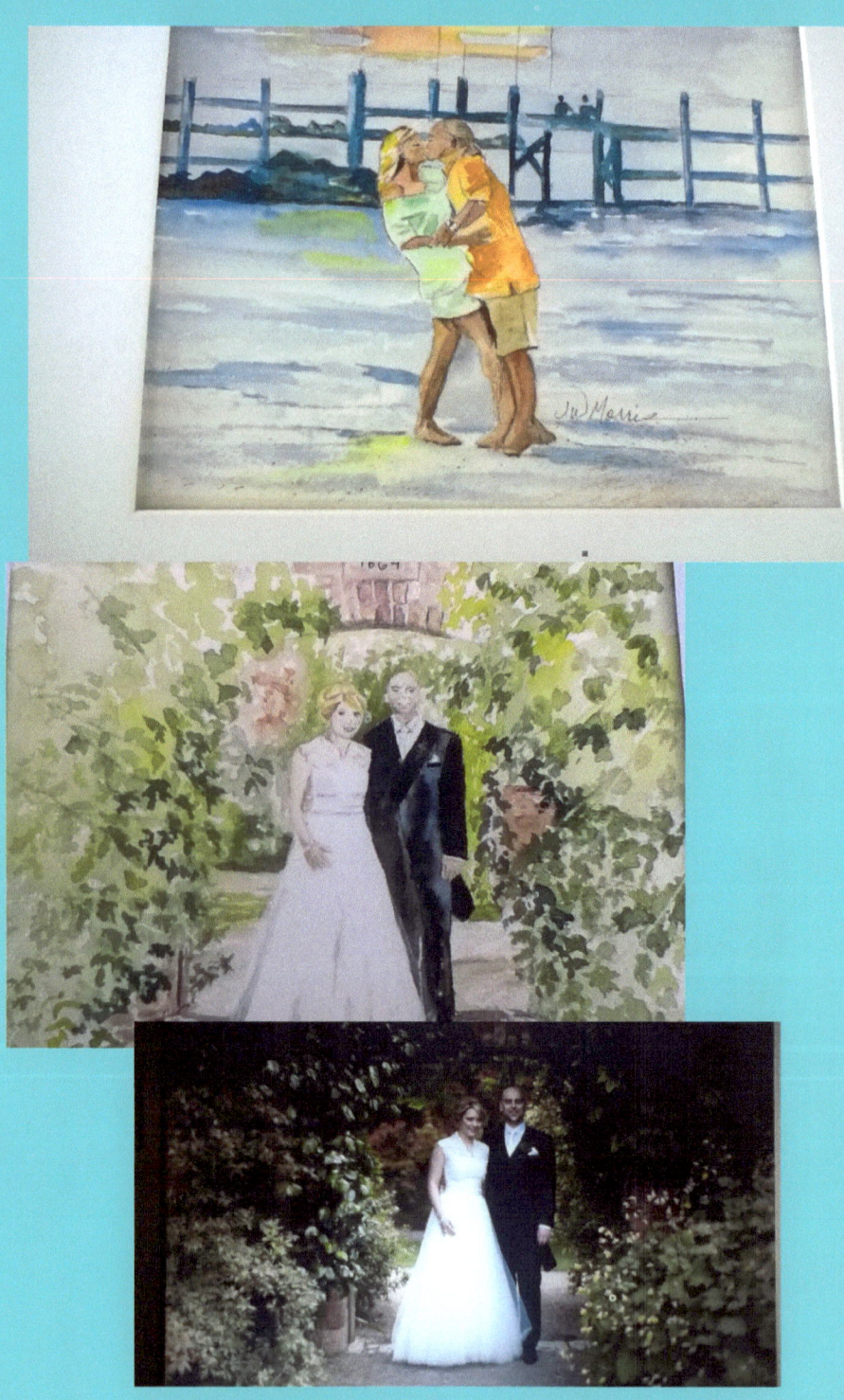

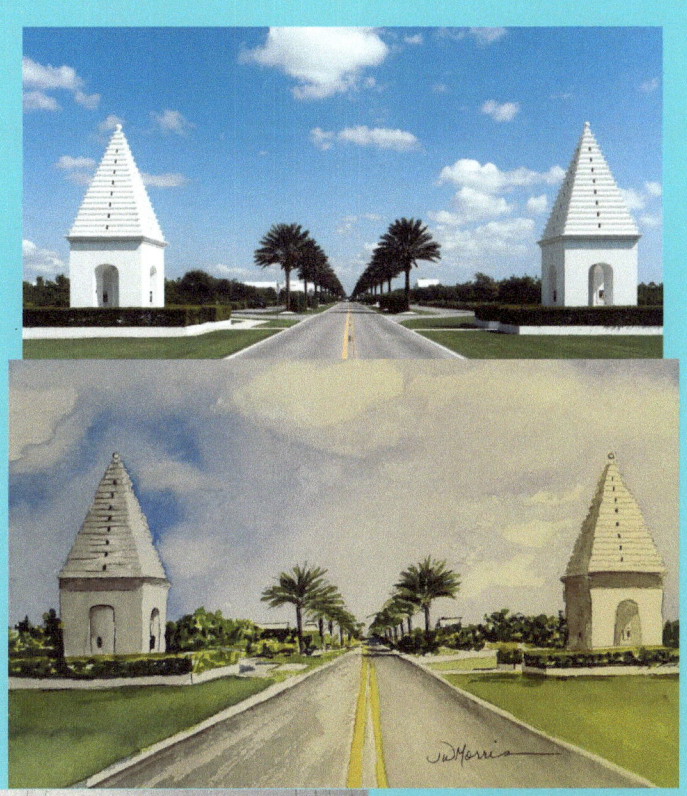
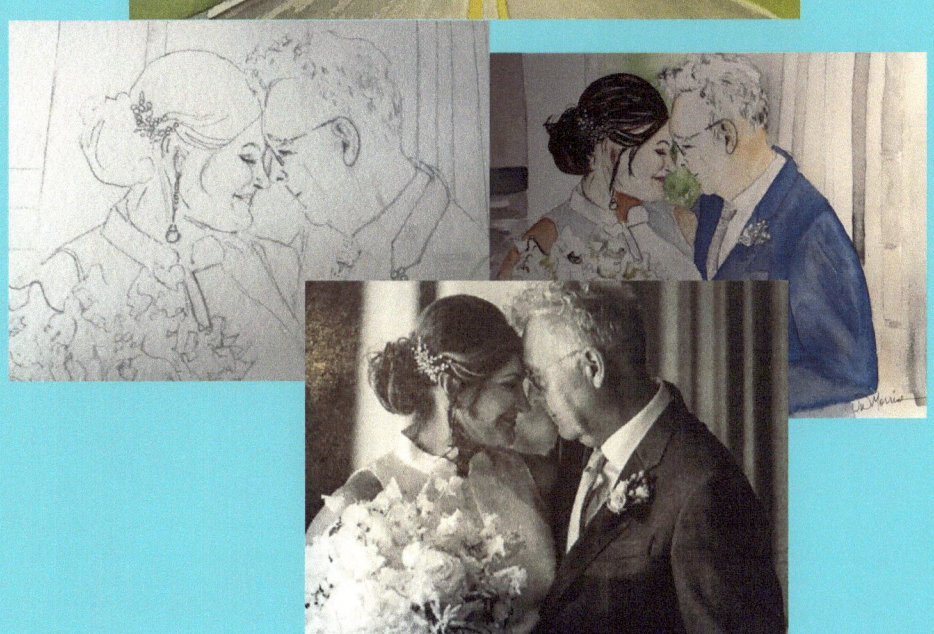

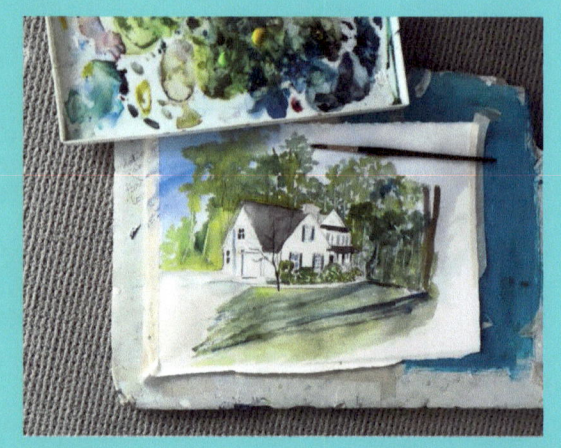

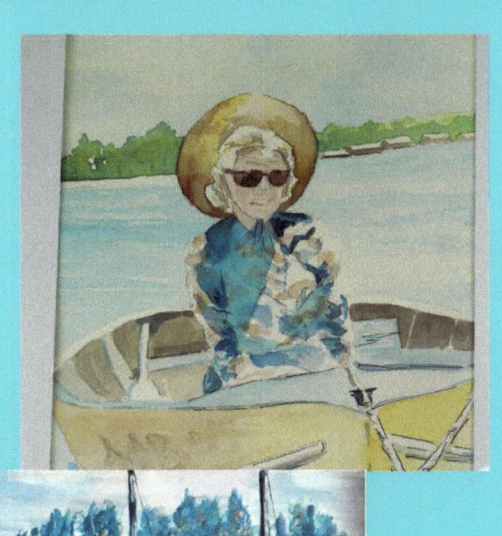
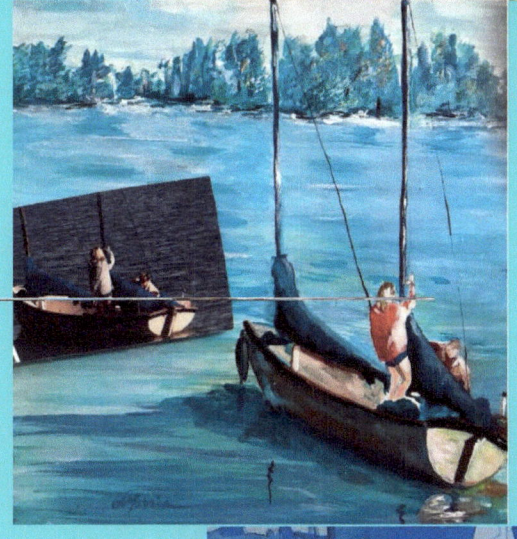
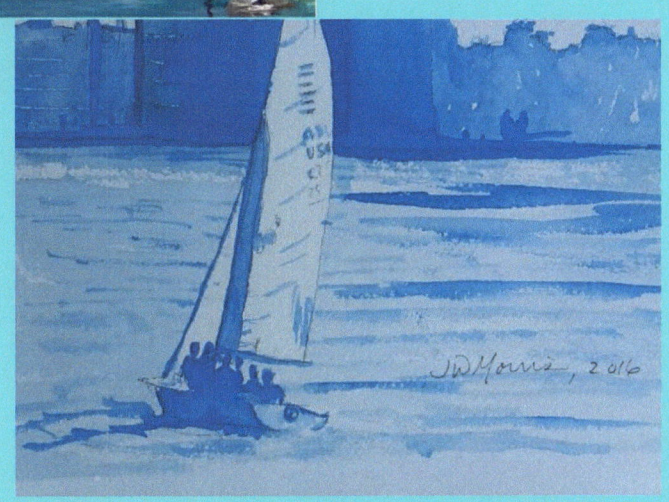

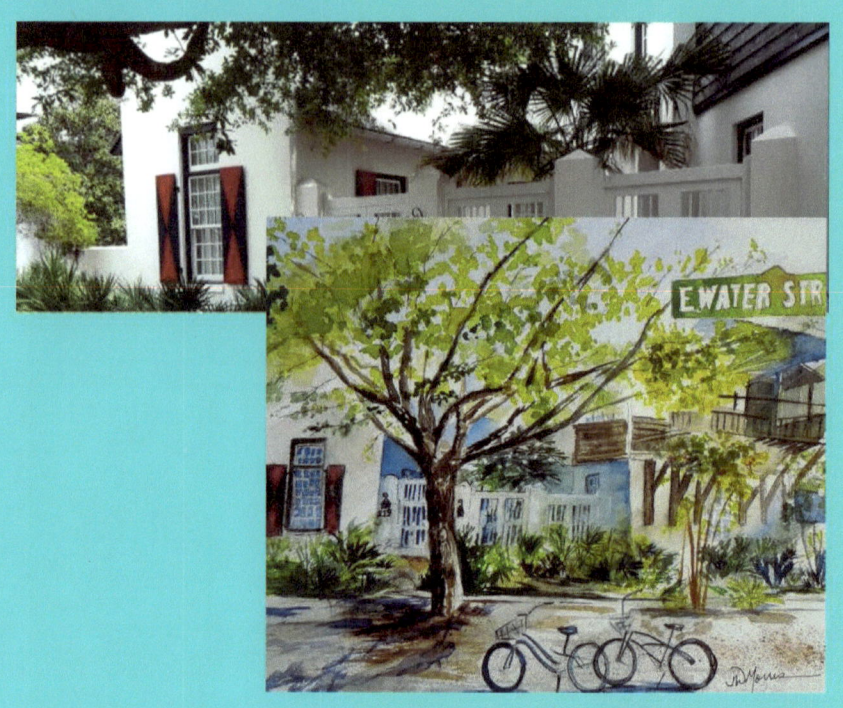
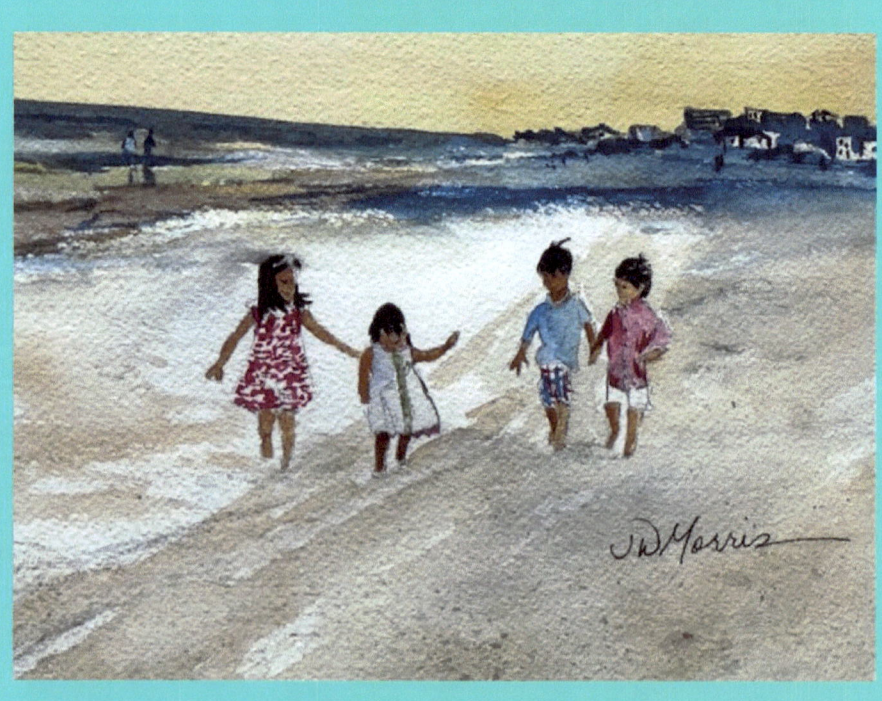

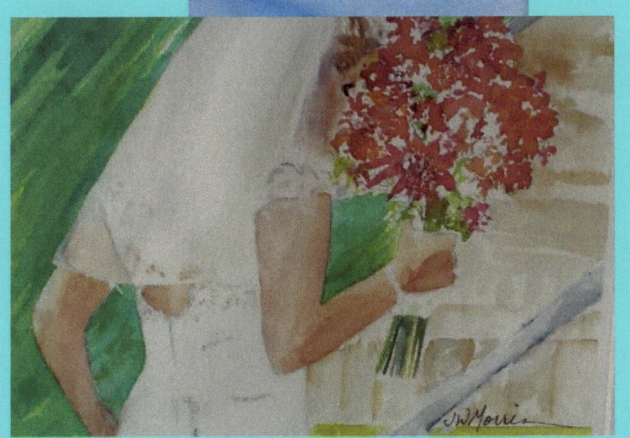

# Bibliography

Agosta, Cristina. *Paint Happy.* Cincinnati: North LIght Books, 2002.

Andrews, Don. Interpreting the Figure in Watercolor. Malaysia: Don Andrews, 1996.

Couch, Tony. Watercolor. You Can Do it! China: Tony Couch, 1987.

Edwards, Betty. Drawing on the Right Side of the Brain. Los Angeles: Tarcher, 1989.

Fritz, Nina. Nina Fritz Paintings. Pensacola: Deborah Dunlap, 1996.

Haines, Jean. Paint Yourself Calm. Turnbridge Wells: Search Press, 2016.

Purcell, Carl. Painting with your Artist's Brain. Cincinnati: North Light Books, 2004.

Quiller, Stephen. Color Choices. New York: Watson-Guptill Publications. 1989.

Waugh, Trevor. Flowers in Watercolor. London: Harper Collins, 2008.

Whitney, Edgar. A., Complete Guide to Watercolor Painting. New York: Watson Guptill Publications, 1974.

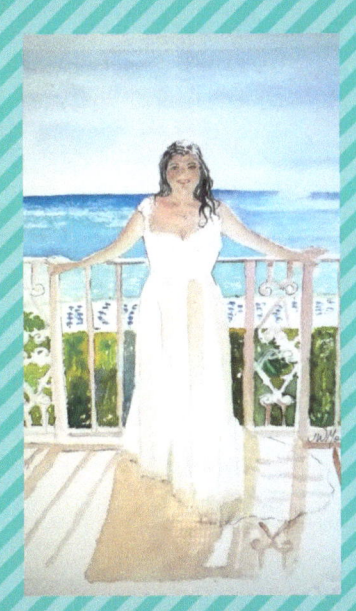

# About the Author

Jill Snyder Morris was born in Johnson City, Tennessee and received a BA from Hollins University in Roanoke, Virginia, and M.Ed. from Kennesaw State University in Kennesaw, Georgia.

While working full time for News Sun Publications in Dekalb, Georgia, Jill pursued art at Lane School of Art in Avondale Estates, Georgia.

Jill later studied in workshops across the country including workshops with Tony Couch, Don Andrews, Frank Webb, Nina Fritz, Tom Lynch, Anne Brodie Hill, Billie Mathes, Joe Miller, and many others.

In addition to teaching workshops, Jill has worked since 1978 as a real estate agent, and currently works at C21 Results in Cumming, Georgia.

**Dedication**
To Benjamin, Jeni, Marcus, Mila, Lois Snyder (mom), and my many friends. Thank you for adding unconditional love to my life.

**Acknowledgements**
Thank you to all of my art students, friends, family and church members who have supported me over the years. Paint therapy is the way I coped during difficult times, and despite my happy outward appearance, I struggled. There is hope, Paint therapy helped me connect positively with God, others, and myself.

# Contributing Photographer, Sharon Paximadis

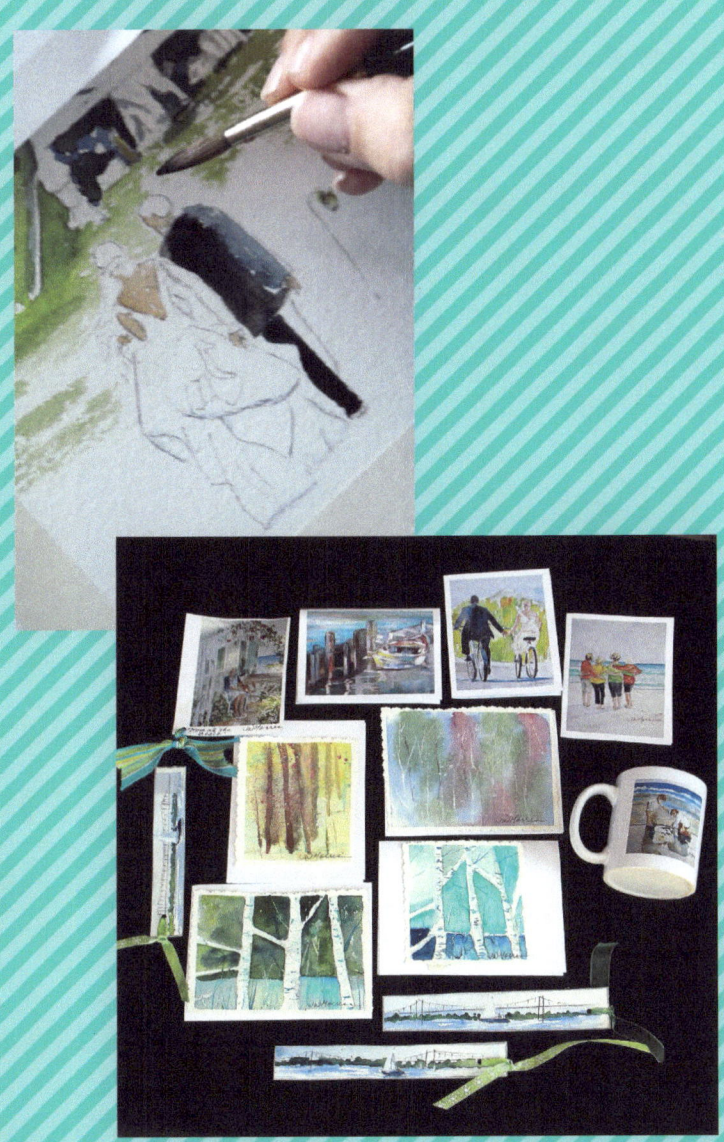

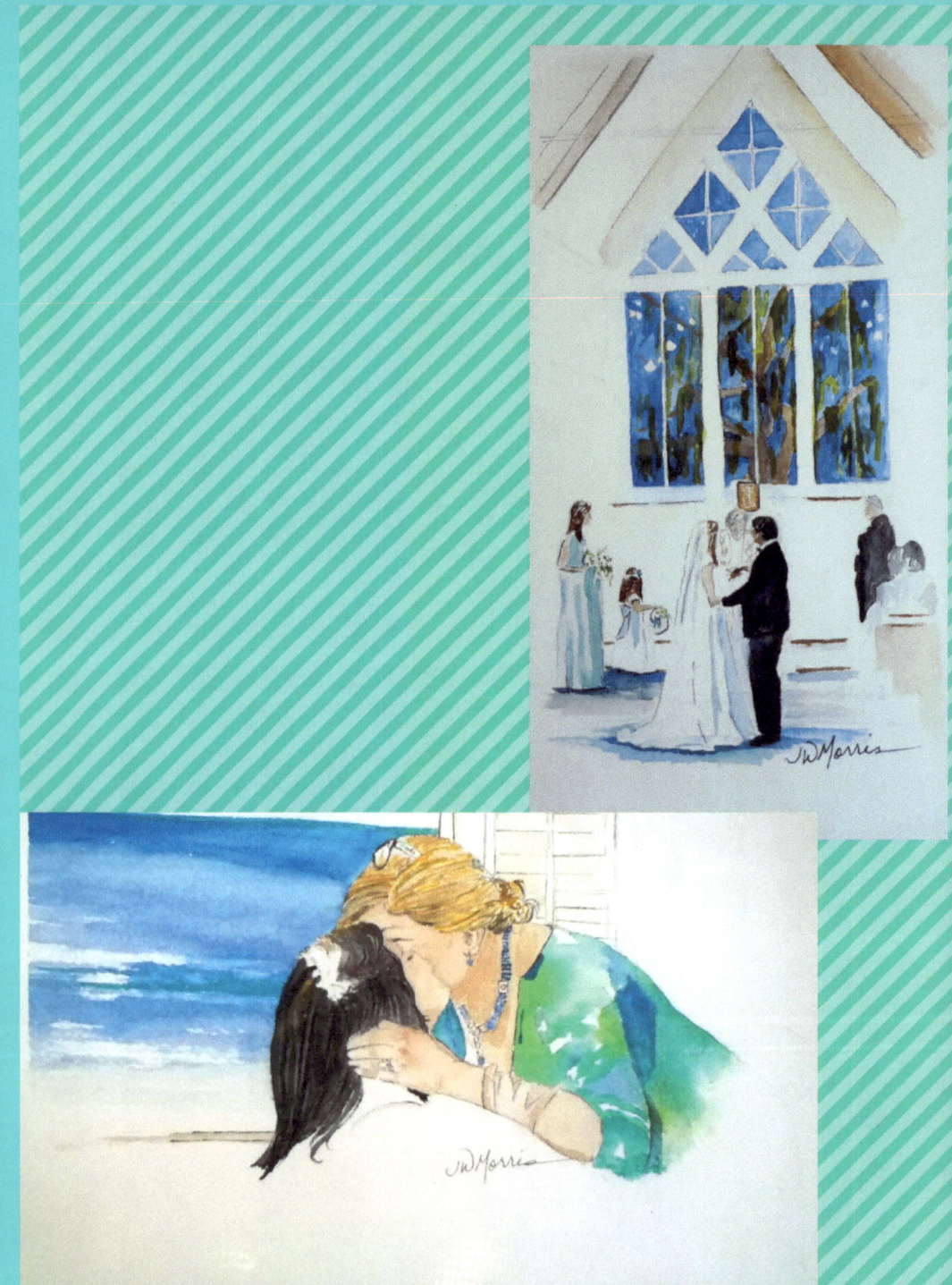

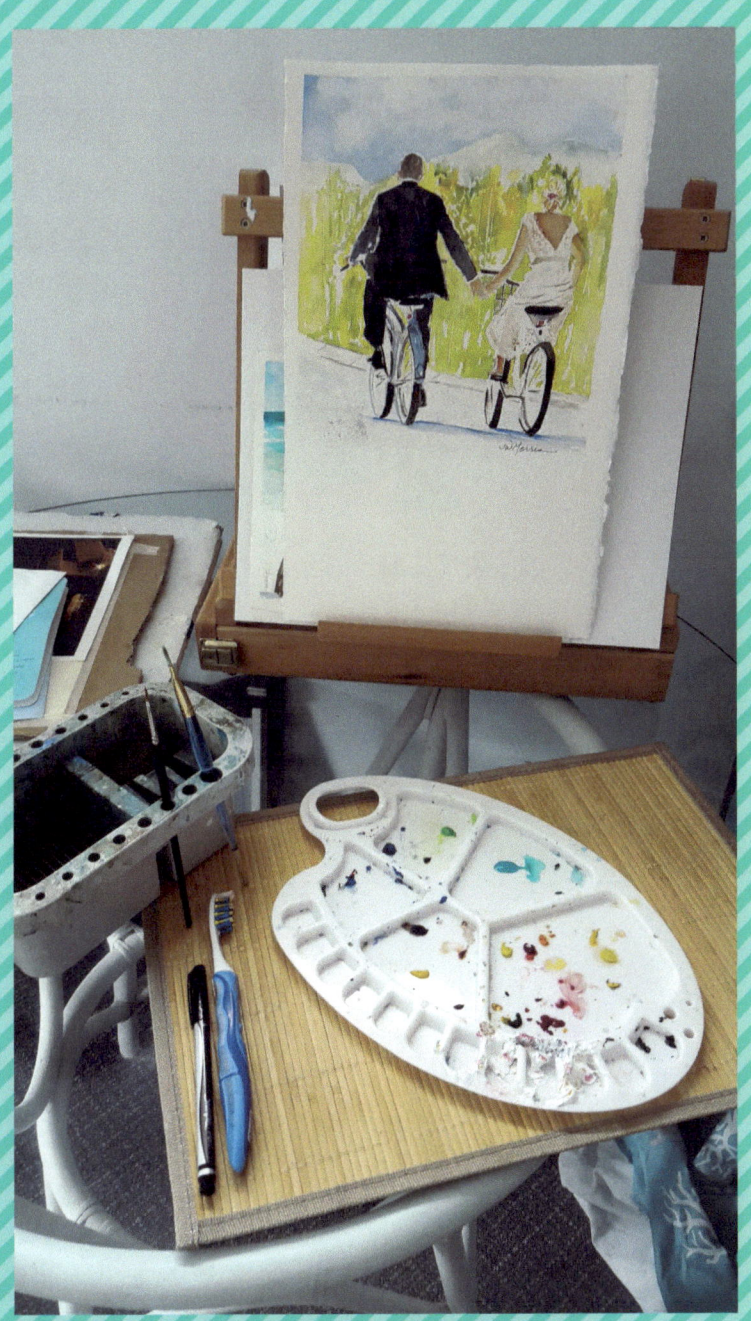

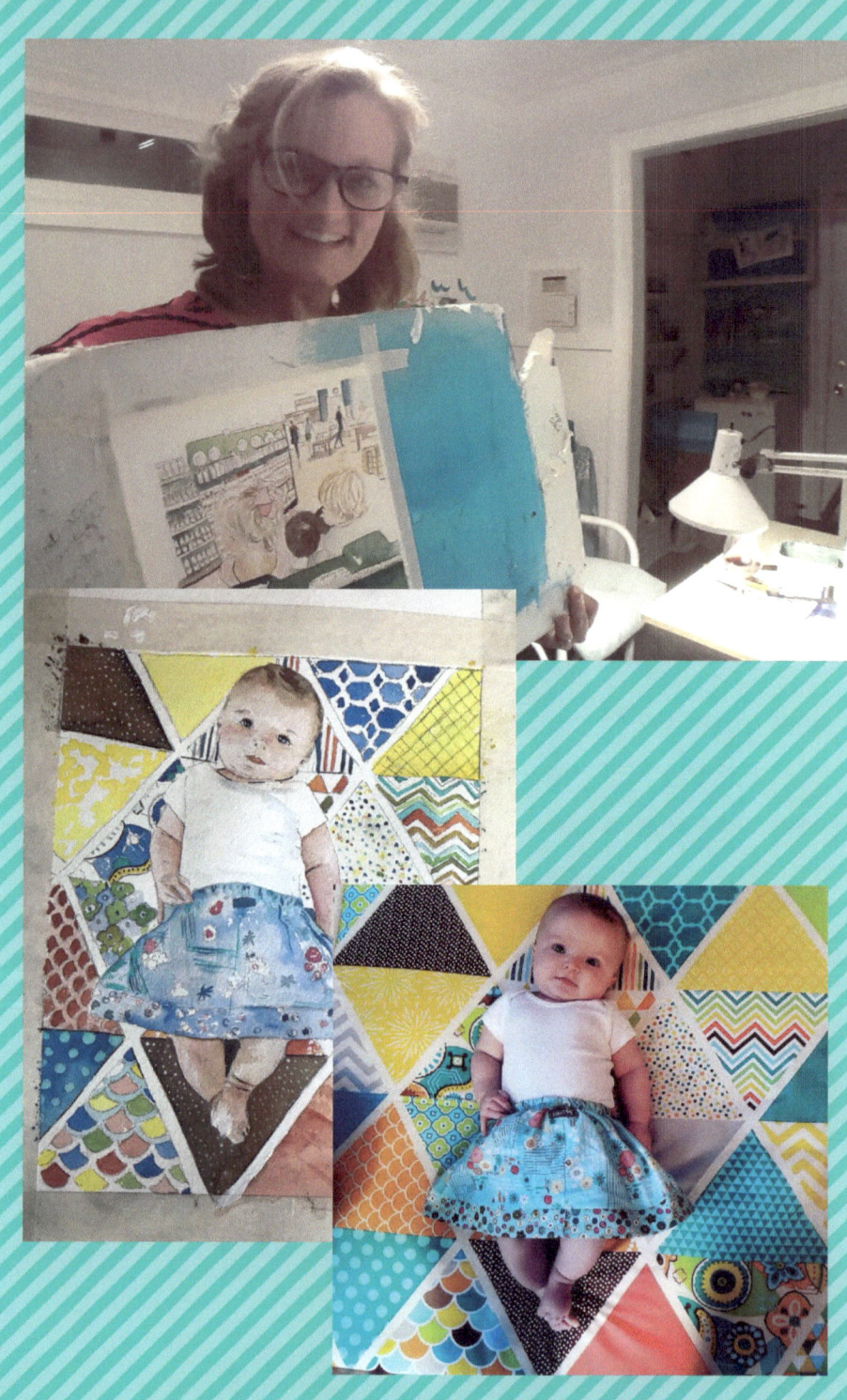

www.ingramcontent.com/pod-product-compliance
Lightning Source LLC
Chambersburg PA
CBHW041113180526
45172CB00001B/232